DATE DUE

4-18-08		

Demco No. 62-0549

WINDOWS THAT OPEN INWARD: IMAGES OF CHILE

Windows That Open Inward: Images of Chile

Photographs by Milton Rogovin

Poems by Pablo Neruda

Edited by Dennis Maloney

Introduction by Pablo Neruda

Translations by Robert Bly, Dennis Maloney, W.S. Merwin,
William O'Daly, Alastair Reid, Janine Pommy Vega, and James Wright

WHITE PINE PRESS · BUFFALO, NEW YORK

The editor wishes to thank the following presses for permission
to reprint the translations listed below:
Beacon Press: "Letter to Miguel Otero Silva, in Caracas," "Cristobal Miranda,"
"Ode to My Socks," "United Fruit Company," "Walking Aound," "The Dictators," "I remember you...,"
"It was the grape's autumn," and "Hymn and Return"
from *Neruda and Vallejo: Selected Poems*,
translated by Robert Bly. Copyright ©1971 by Robert Bly.
Reprinted by permission of Robert Bly.

Dell Publishing Company: "Ode to the Clothes" from *The Selected Poems of Pablo Neruda*
edited by Nathanial Tarn and translated by W.S. Merwin.
Copyright ©1972 by Dell Publishing Company.
Reprinted by permission of Dell Publishing Company.

Farrar, Straus & Giroux, Inc.: "For Everyone," "The Builder," and "To Wash a Child"
from *Fully Empowered*; "Pastoral," "Old Women of the Shore," "To the Foot from Its Child,"
and "Too Many Names" from *Extravagaria*; and "Oh, Earth, Wait for Me" and "Memory"
from *Isla Negra* translated by Alastair Reid.
Copyright ©1972, 1975, 1981 by Farrar, Straus & Giroux, Inc.
Used by permission of Farrar, Straus & Giroux, Inc.

Copper Canyon Press: "Still Another Day, Section IV" and "Salud, We Call Out Every Day..."
from *The Sea and the Bells* translated by William O'Daly. Copyright ©1984, 1988.
Reprinted by permission of Copper Canyon Press,
P.O. Box 271, Port Townsend, WA 98368.

Publication of this book was made possible by grants from
the National Endowment For the Arts, the New York State Council on the Arts,
and the City of Buffalo.

Book design: Elaine LaMattina

Printed and bound in the United States of America.

Published by White Pine Press
P.O. Box 236 • Buffalo, NY 14201

LIBRARY OF CONGRESS CATALOGING-IN-PUBLICATION DATA

Rogovin, Milton, 1909-
Windows that open inward / photographs by Milton Rogovin ;
poems by Pablo Neruda ; edited by Dennis Maloney ;
introduction by Pablo Neruda ; translations by Robert Bly ... [et al.].
p. cm.
ISBN 1-877727-89-X (alk. paper)
1. Chile—Pictorial works. 2. Chiloé Island (Chile)—Pictorial works. 3. Chile—Poetry.
4. Neruda, Pablo, 1904-1973—Translations into English.
I. Neruda, Pablo, 1904-1973. Poems. Selections. II. Maloney, Dennis. III. Bly, Robert. IV. Title.
F3065.R64 1998
983—dc21 98-49201
CIP

CONTENTS

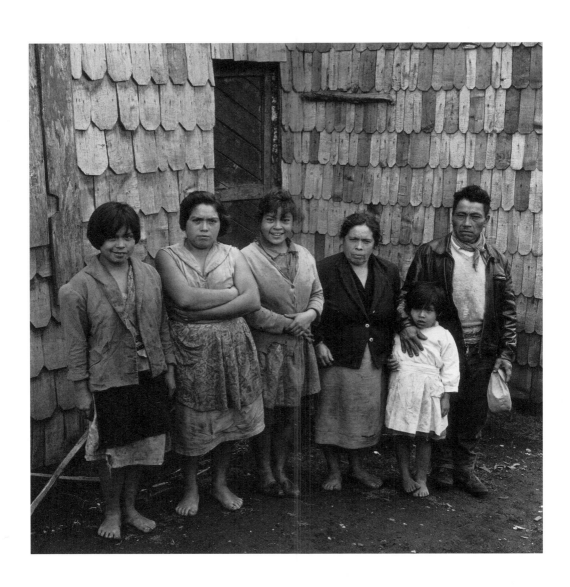

Isla Negra,
13 Nov. 66

Dear friend,

Your work is wonderful and
I will be greatly honoured if
we collaborate in any venture.

There is a big island:
Chiloe, in the far South. I think
that will do. It is wonderfully
untouched, poor and full of
human interest. I could go
with you this summer, January
February 1967 or next summer
1968 ?

Tell me all about your
possibilities and you
have here a friend,

Yours

Pablo
Neruda

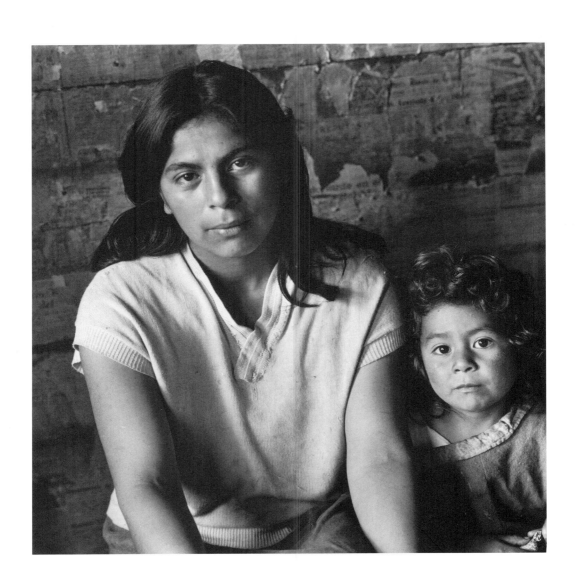

The Islands and Rogovin

I did not know Milton Rogovin.

His letter asked me an uncommon question. He wanted to photograph the truth. I suggested that he come to our Southern-most part, to the Archipeligo, to Quemchi, to Chonchi, to sleepy shores of the South of the Americas.

He arrived quickly, well-equipped and efficient: North American. He came loaded down with lenses and cameras. He was too much for our simplicity. I recommended to him a good umbrella. He went ahead to the remote villages.

But he carried much more than his equipment. Eyes patient and searching. A heart sensitive to light, to rain, to shadows.

Soon he returned and left us. He went back to Kansas, Oregon, and Mississippi. But this time he took along with him a bouquet of wonderful images; the portrait of the truth. Portrait of humble truth that is lost in the inclemency of the islands.

Walls of humble homes with windows that open inward to the mythology, to the whispering, to the black clothes. Eyes, penetrating and dark, with sparks buried, like forgotten embers glowing in fireplaces where once fire burned so intensely.

Rogovin photographed the silence. Left intact in their mystery those insular depths of the islands which are revealed to us in simple objects, in crystalline poetry, as if the little village were living underwater with legendary belfries next to anchors of mythological vessels.

The great photographer immersed himself in the poetry of simplicity and came to the surface with the net full of clear fish and flowers of profundity.

Because the earth is extremely unfaithful, it offers itself to the foreign eye and deceives our eyes, our indifference, our ways.

Rogovin had to come, photographer of the poor Negro, of the black liturgy, of the humiliated children of the North, so that he may uncover for us of the South, and so that he can take with him the truth of the South, with those dark eyes which looked at us and at what we did not see with the pathetic and poetic poverty of the fatherland which we love and do not know.

—Pablo Neruda
Isla Negra

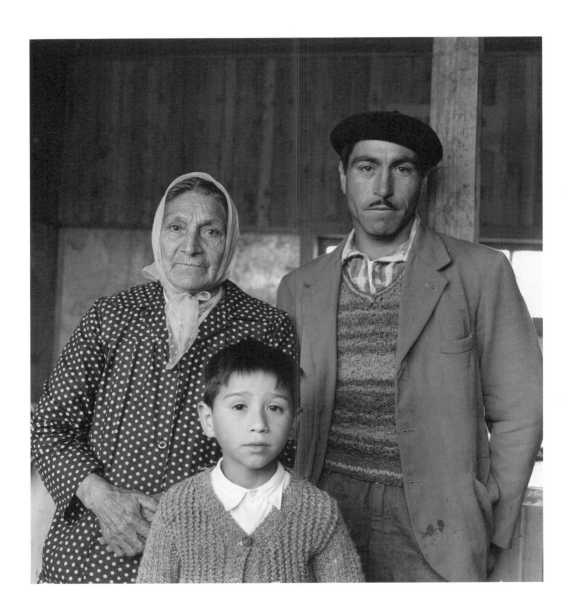

For Everyone

I can't just suddenly tell you
what I should be telling you.
Friend, forgive me: you know
that although you don't hear my words,
I wasn't asleep or in tears,
that I'm with you without seeing you
for a good long time and until the end.

I know that many may wonder
"What is Pablo doing?" I'm here.
If you look for me in this street
you'll find me with my violin,
prepared to break into song,
prepared to die.

It is nothing I have to leave to anyone,
not to these others, not to you,
and if you listen well, in the rain, you'll hear
that I come and go and hang about.
And you know that I have to leave.

Even if my words don't know it,
be sure, I'm the one who left.
There is no silence which doesn't end.
When the moment comes, expect me
and let them all know I'm arriving
in the street, with my violin.

Translated by Alastair Reid

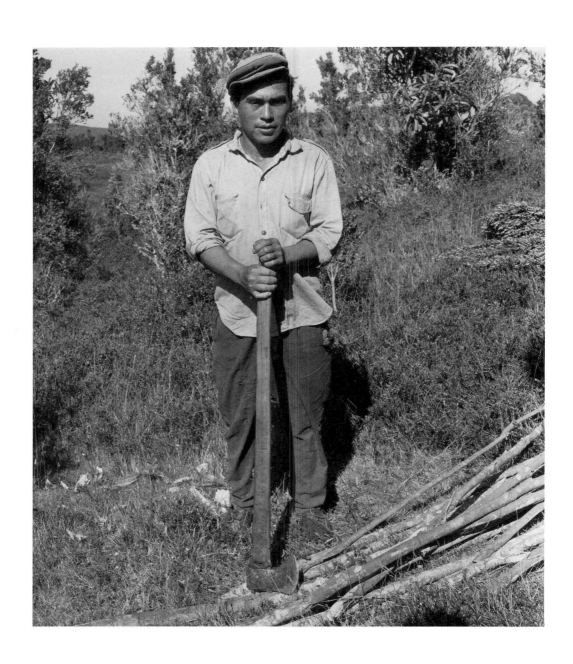

from *Still Another Day*

VI

Pardon me, if when I want
to tell the story of my life
it's the land I talk about.
This is the land.
It grows in your blood
and you grow.
If it dies in your blood
you die out.

Translated by William O'Daly

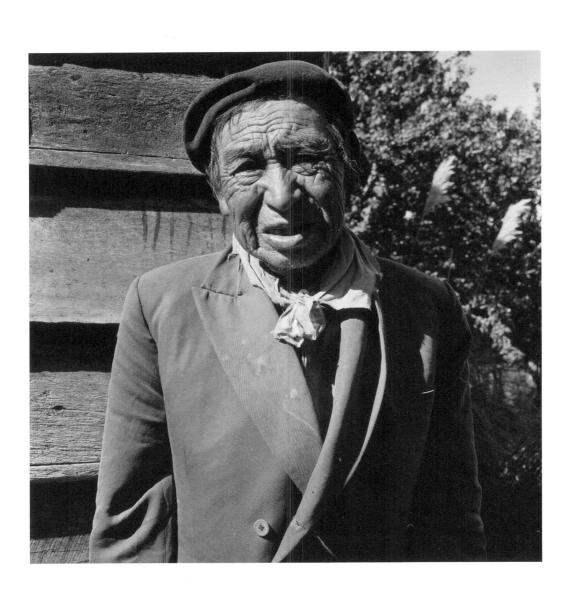

"It Was the Grape's Autumn"

It was the grape's autumn.
The dense vinefield shivered.
The white clusters, half-hidden,
found their mild fingers cold,
and the black grapes were filling
their tiny stout udders
from a round and secret river.
The man of the house, an artisan
with a hawk's face, read to me
the pale earth book
about the darkening days.
His kindliness saw deep into the fruit,
the trunk of the vine, and the work
of the pruning knife, which lets the tree keep
its simple goblet shape.
He talked to his horses
as if to immense boys: behind him
the five cats trailed,
and the dogs of that household,
some arched and slow moving,
others running crazily
under the cold peach trees.
He knew each branch,
each scar on his trees,
and his ancient voice taught me
while it was stroking his horses.

Translated by James Wright
and Robert Bly

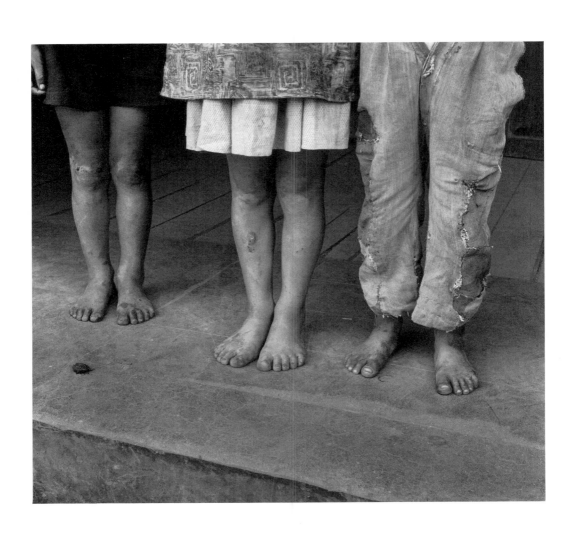

To the Foot From Its Child

The child's foot is not yet aware it's a foot
and would like to be a butterfly or an apple.

But in time, stones and bits of glass,
streets, ladders,
and the paths in the rough earth
go on teaching the foot that it cannot fly,
cannot be a fruit bulging on the branch.
Then, the child's foot
is defeated, falls
in the battle,
is a prisoner
condemned to live in a shoe.

Bit by bit, in that dark,
it grows to know the world in its own way,
out of touch with its fellow, enclosed,
feeling out of life like a blind man.

These soft nails
of quartz, bunched together,
grow hard, and change themselves
into opaque substance, hard as horn,
and the tiny, petalled toes of the child
grow bunched and out of trim,
take on the form of eyeless reptiles
with triangular heads, like worms.
Later, they grow calloused
and are covered
with the faint volcanoes of death,
a coarsening hard to accept.

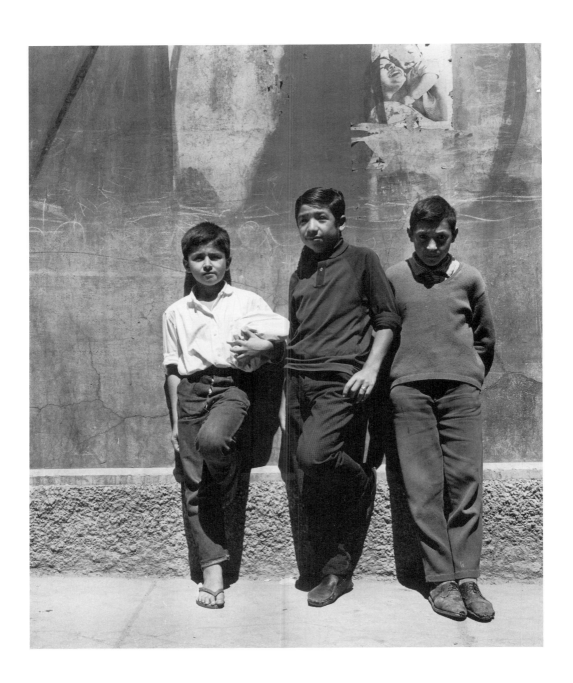

But this blind thing walks
without respite, never stopping
for hour after hour,
the one foot, the other,
now the man's,
now the women's,
up above,
down below,
through fields, mines,
markets and ministries,
backwards,
far afield, inward,
forward, this foot toils in its shoe,
scarcely taking time
to bare itself in love or sleep;
it walks, they walk,
until the whole man chooses to stop.

And then it descended
underground, unaware,
for there, everything, everything was dark.
It never knew it had ceased to be a foot
or if they were burying it so that it could fly
or so that it could become
an apple.

Translated by Alastair Reid

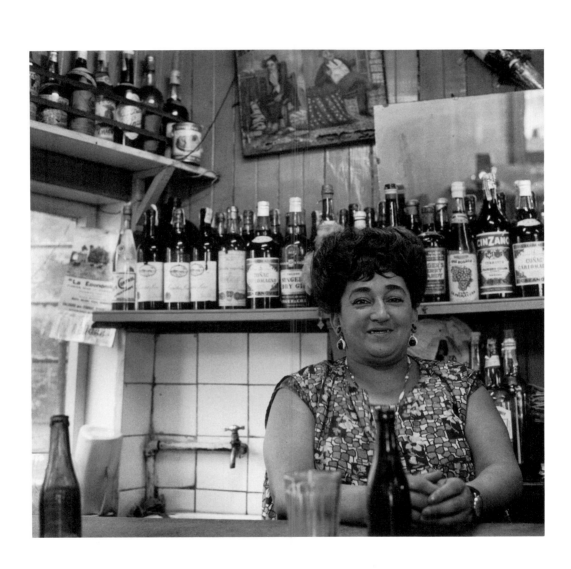

Salud

Salud, we called out every day,
to every single person,
it is the calling card
of false kindness
and of sincerity.
It's the bell we are known by:
here we are, salud!
You hear it clearly, we exist.
Salud, salud, salud,
to this one and that one
and the other one,
to the poisoned knife
and to the assassin.
Salud, recognize me,
we are equal and do not like each other,
we love each other and are not equal,
each of us with a spoon,
with our own sad story,
haunted by being and not being:
we all need to have so many hands,
and so many lips to smile,
salud!
time has already passed.
Salud
to getting to know nothing.
Salud
to devoting ourselves to ourselves,
if anything remains of us,
of ourselves.
Salud!

Translated by William O'Daly

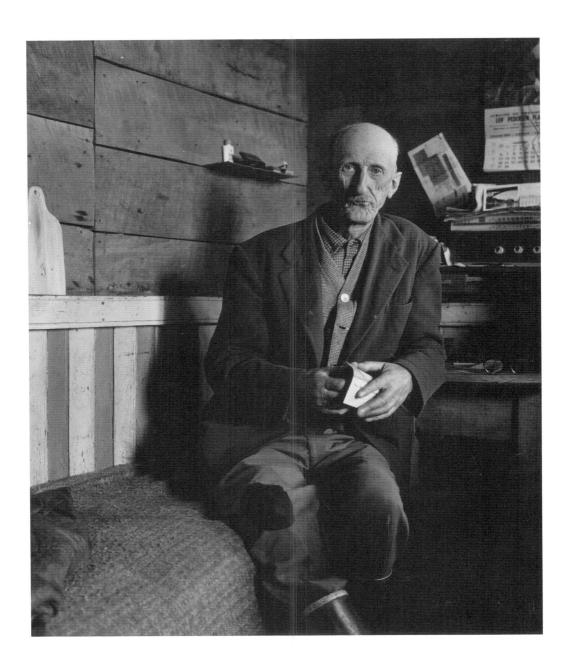

Walking Around

It so happens I am sick of being a man.
And it happens that I walk into tailor shops and movie houses
dried up, waterproof, like a swan made of felt
steering my way in a water of wombs and ashes.

The smell of barber shops makes me break into hoarse sobs.
The only thing I want is to lie still like stones or wool.
The only thing I want is to see no more stores, no gardens,
no more goods, no spectacles, no elevators.

It so happens I am sick of my feet and my nails
and my hair and my shadow.
It so happens I am sick of being a man.

Still it would be marvelous
to terrify a law clerk with a cut lily,
or kill a nun with a blow on the ear.
It would be great
to go through the streets with a green knife
letting out yells until I die of the cold.

I don't want to go on being a root in the dark,
insecure, stretched out, shivering with sleep,
going on down, into the moist guts of the earth,
taking in and thinking, eating everyday.

I don't want so much misery.
I don't want to go on as a root and a tomb,
alone under the ground, a warehouse with corpses,
half frozen, dying of grief.

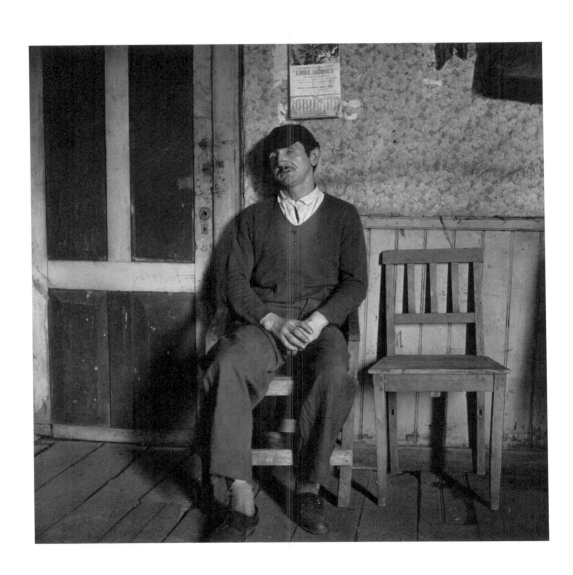

That's why Monday, when it sees me coming
with my convict face, blazes up like gasoline,
and it howls on its way like a wounded wheel,
and leaves tracks full of warm blood leading toward the night.
And it pushes me into certain corners, into some moist houses,
into hospitals where the bones fly out the window,
into shoe shops that smell like vinegar,
and certain streets hideous as cracks in the skin.

There are sulphur-colored birds, and hideous intestines
hanging over the doors of houses that I hate,
and there are false teeth forgotten in a coffeepot,
there are mirrors
that ought to have wept from shame and terror,
there are umbrellas everywhere, and venoms, and umbilical cords.

I stroll along serenely, with my eyes, my shoes,
my rage, forgetting everything,
I walk by, going through office buildings and orthopedic shops,
and courtyards with washing hanging from the line:
underwear, towels and shirts from which slow
dirty tears are falling.

Translated by Robert Bly

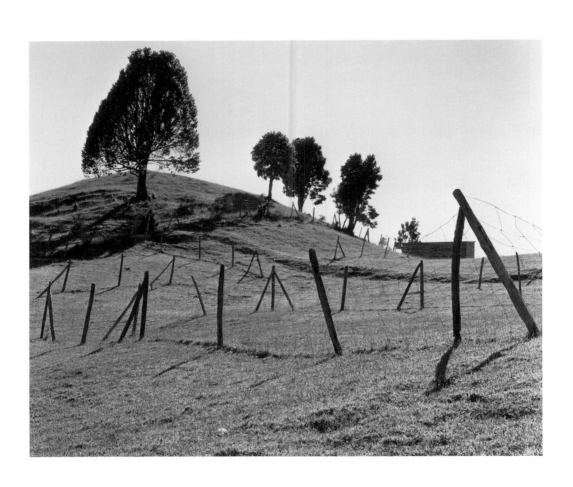

Pastoral

I copy out mountains, rivers, clouds.
I take my pen from my pocket. I note down
a bird in its rising
or a spider in its little silk works.
Nothing else crosses my mind. I am air,
clear air, where the wheat is waving,
where a bird's flight moves me, the uncertain
fall of a leaf, the globular
eyes of a fish unmoving in the lake,
the statues sailing in the clouds,
the intricate variations of the rain.

Nothing else crosses my mind except
the transparency of summer. I sing only of the wind,
and history passes in its carriage,
collecting its shrouds and medals,
and passes, and all with the spring.

Shepherd, shepherd, don't you know
they are all waiting for you?

I know, I know, but here beside the water
while the locusts chitter and sparkle,
although they are waiting, I want to wait for myself.
I too want to watch myself.
I want to discover at last my own feelings.
And when I reach the place where I am waiting,
I expect to fall asleep, dying of laughter.

Translated by Alastair Reid

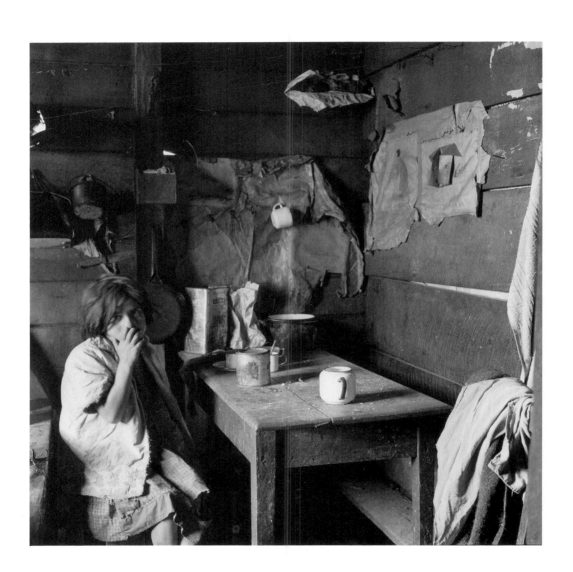

The Great Stone Table

We arrive at the great stone table
the children of Lota, Quepe,
Quitratue and Metrenco.
Of Ranquilco, Selva Oscura,
Yumbel, Yungay and Osorno.

We sit by the table,
the cold table of the world
and no one has brought us anything.
Everything was consumed,
they had eaten all of it.

One plate alone remains, waiting
on the immense hard table
of the world and the void.
Still a child waits
who is the truth of every dream,
who is the hope of our earth.

Translated by Dennis Maloney

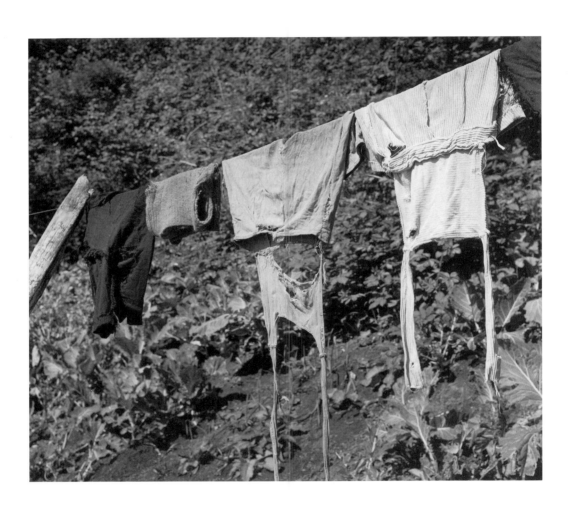

Ode to the Clothes

Every morning you wait,
clothes, over a chair,
for my vanity,
my love,
my hope, my body
to fill you,
I have scarcely
left sleep,
I say goodbye to the water
and enter your sleeves,
my legs look for
the hollow of your legs,
and thus embraced
by your unwearying fidelity
I go out to tread the fodder,
I move into poetry,
I look through windows,
at things,
men, women,
actions and struggles
keep making me what I am,
opposing me,
employing my hands,
opening my eyes,
putting taste in my mouth,
and thus,
clothes,
I make you what you are,
pushing out your elbows,
bursting the seams,
and so your life swells
the image of my life.

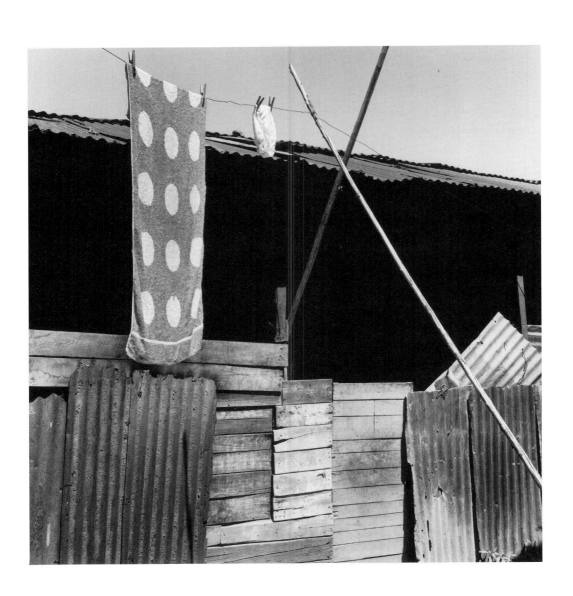

You billow
and resound in the wind
as though you were my soul,
at bad moments
you cling
to my bones
empty, at night
the dark, sleep,
people with their phantoms
your wings and mine.

I ask
whether one day
a bullet
from the enemy
will stain you with my blood
and then
you will die with me
or perhaps
it may not be
so dramatic
but simple,
and you will sicken gradually,
clothes,
with me, with my body
and together
we will enter
the earth.
At the thought of this
every day
I greet you
with reverence, and then
you embrace me and I forget you
because we are one
and will go on facing
the wind together, at night.
the streets or the struggle,
one body,
maybe, maybe, one day motionless.

Translated by W.S. Merwin

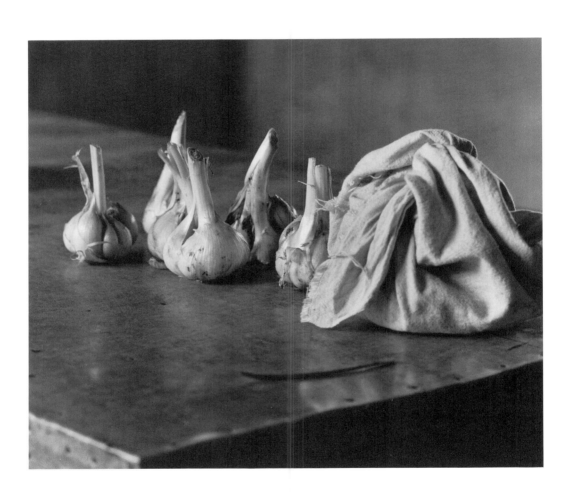

Ode To A Woman Gardener

Yes, I knew that your hands were
a gilliflower in bloom, the lily
of silver:
anything that had to do
with the soil,
with the blossoming of the earth.
But,
when
I saw you digging, digging,
removing small stones
and overcoming roots,
I suddenly knew,
my farmer,
that not only
your hands
but your heart
was of the earth,
that there
you understood
and made
things yours,
touching
moist
doors
through which
whirl
the seeds.

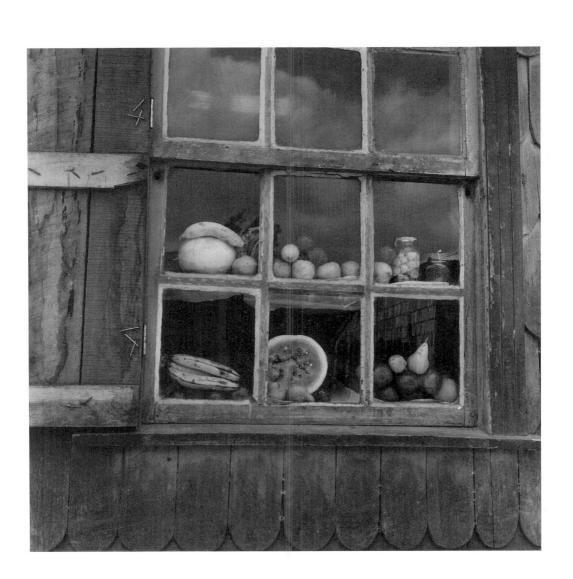

Thus, as,
one plant after another
newly planted,
your face
stained
by a kiss
of mud,
you go out
and return
flourishing,
you go out
and from your hand
the stem
of the alstromeria
raises its elegant solitude,
the jasmine
graces
the mist of your forehead
with stars of perfume and the dew.

All
of you grew,
penetrating
into the earth,
and made
immediate
green light,
foliage and power.
You communicated with
your seeds,
my love,
ruby gardener:
your hand
your self
with the earth
and suddenly the clear
growth of a garden.

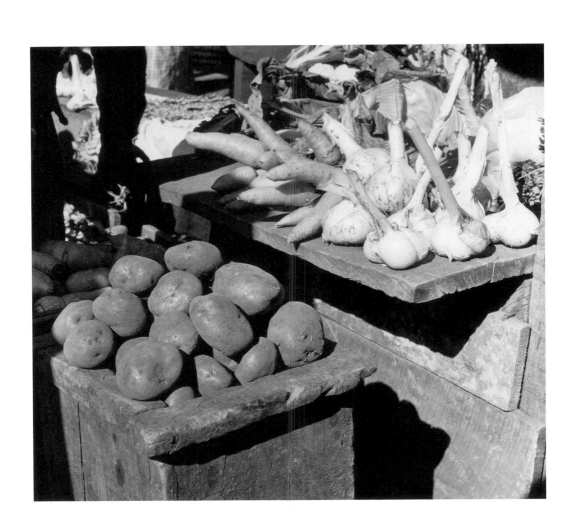

Love, so too
your hand
of water,
your heart of earth
gave fertility
and strength to my song.
You touched
my breast
while I slept
and the trees budded
in my dreams.
I woke up, opened my eyes,
and you had planted
inside of me
astonishing stars
that rise
with my song.

So it is, gardener:
our love
is
of the earth:
your mouth is a plant of light, a corolla,
my heart works in the roots.

Translated by Dennis Maloney

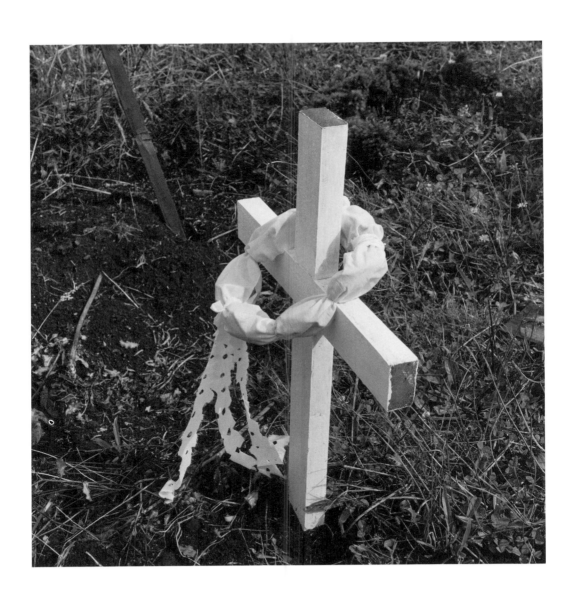

Cristobal Miranda

(Shoveler at Tocopilla)

I met you on the broad barges
in the bay, Cristobal, while the sodium nitrate
was coming down, wrapped in a burning
November day, to the sea.
I remember the ecstatic nimbleness,
the hills of metal,
the motionless water.
And only the bargemen, soaked
with sweat, moving snow.
Snow of the nitrates, poured
over painful shoulders, dropping
into the blind stomach of the ships.
Shovelers there, heroes of a sunrise
eaten away by acids, and bound
to the destinies of death, standing firm,
taking in the floods of nitrate.
Cristobal, this memento is for you,
for the others shoveling with you,
whose chests are penetrated by the acids
and the lethal gases,
making the heart swell up
like crushed eagles, until the man drops,
rolls toward the streets of town,
toward the broken crosses out in the field.
Enough of that, Cristobal, today
this bit of paper remembers you, each of you,
the bargemen of the bay, the men
turned black in the boats, my eyes
are moving with yours in this daily work
and my soul is a shovel which lifts
loading and unloading blood and snow
next to you, creatures of the desert.

Translated by Robert Bly

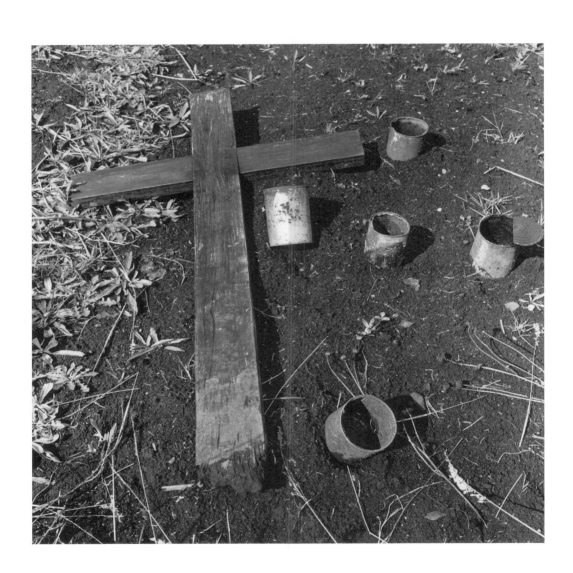

The Dictators

An odor has remained among the sugarcane:
a mixture of blood and body, a penetrating
petal that brings nausea.
Between the coconut palms the graves are full
of ruined bones, of speechless death-rattles.
The delicate dictator is talking
with tops hats, gold braid, and collars.
The tiny palace gleams like a watch
and the rapid laughs with gloves on
cross the corridors at times
and join the dead voices
and the blue mouths freshly buried.
The weeping cannot be seen, like a plant
whose seeds fall endlessly on the earth,
whose large blind leaves grow even without light.
Hatred has grown scale on scale,
blow on blow, in the ghastly water of the swamp,
with a snout full of ooze and silence.

Translated by Robert Bly

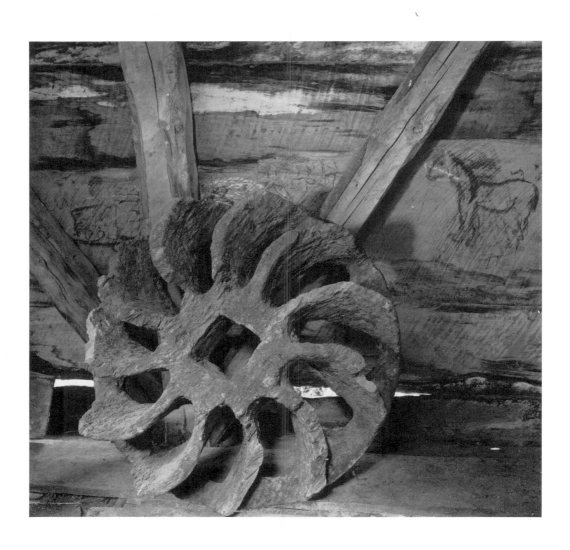

Too Many Names

Mondays are meshed with Tuesdays
and the week with the whole year.
Time cannot be cut
with your exhausted scissors,
and all the names of the day
are washed out by the waters of night.

No one can claim the name of Pedro,
Nobody is Rosa or Maria,
all of us are dust or sand,
all of us are rain under rain.
They have spoken to me of Venezuelas,
of Chiles and Paraguays;
I have no idea what they are saying.
I know only the skin of the earth
and I know it has no name.

When I lived amongst the roots
they pleased me more than flowers did,
and when I spoke to a stone
it rang like a bell.

It is so long, the spring
which goes on all winter.
Time lost its shoes.
A year lasts four centuries.

When I sleep every night,
what am I called or not called?
And when I wake, who am I
if I was not I while I slept?

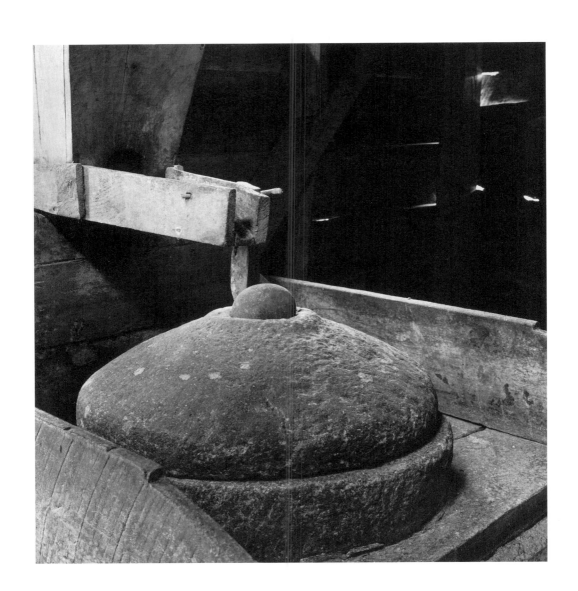

This means to say that scarcely
have we landed into life
than we come as if new-born:
let us not fill our mouths
with so many faltering names,
with so many sad formalities,
with so many pompous letters,
with so much of yours and mine,
with so much signing of papers.

I have a mind to confuse things,
unite them, make them new-born,
mix them up, undress them,
until all light in the world
has the oneness of the ocean,
a generous, vast wholeness,
a crackling, living fragrance.

Translated by Alastair Reid

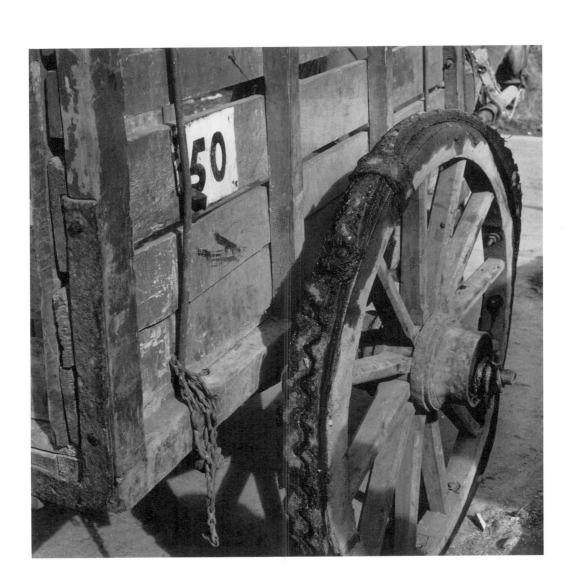

Some Thoughts On An Impure Poetry

It is worthwhile, at certain hours of the day or night, to look closely at useful objects at rest. Wheels that have crossed long, dusty distances with their enormous loads of crops or ore, sacks from coal, barrels, baskets, the handles and hafts of carpenters' tools. The contact these objects have had with the earth serve as a text for all tormented poets. The worn surfaces of things, the wear that hands give to them, the air, sometimes tragic, sometimes pathetic, emanating from these objects lends an attractiveness to the reality of the world that should not be scorned.

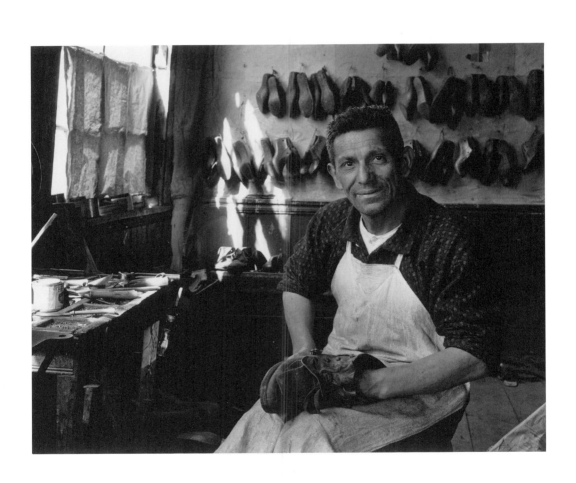

In them one sees the confused impurity of the human condition, the massing of things, the use and obsolescence of materials, the mark of a hand, footprints, the abiding presence of the human that permeates all artifacts.

This is the poetry we search for, worn with the work of hands, corroded as if by acids, steeped in sweat and smoke, reeking of urine and smelling of lilies soiled by the diverse trades we live by both inside the law and beyond it.

A poetry impure as the clothing we wear or our bodies, a poetry stained with soup and shame, a poetry full of wrinkles, dreams, observations, prophecies, declarations of love and hate, idylls and beasts, manifestos, doubts, denials, affirmations and taxes.

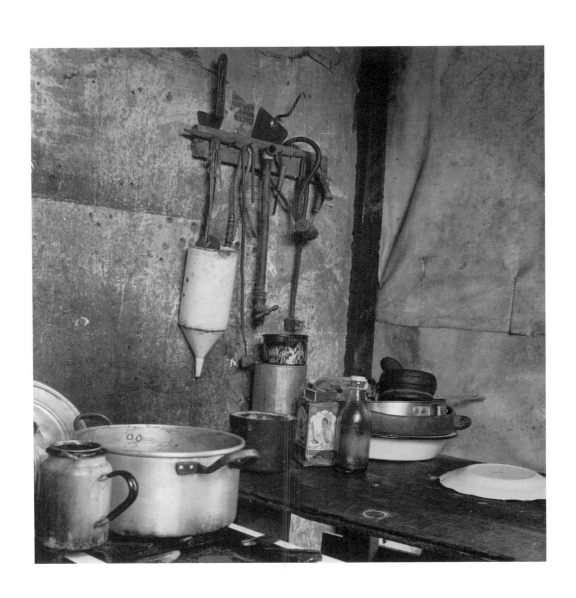

The sacred canons of the madrigal and the demands of touch, smell, taste, sight and hearing, the passion for justice and sexual desire, the sound of the sea—accepting and rejecting nothing: the deep penetration into things in the quest of love, a complete poetry soiled by the pigeon's claw, tooth-marked and scarred by ice, etched delicately with our sweat and use. Until the surface of an instrument is worn smooth through constant playing and the hard softness of rubbed wood reveals the pride of the maker. Blossom, wheat kernel and water share a special character, the profuse appeal of the tactile.

We must not overlook melancholy, sentimentality, the perfect impure fruit of a species abandoned by a penchant for pendantry—moonlight, the swan at dusk, all the hackneyed endearments, surely they are the elemental and essential matter of poetry.

He who would shun "bad taste" in things will fall on his face.

Translated by Dennis Maloney

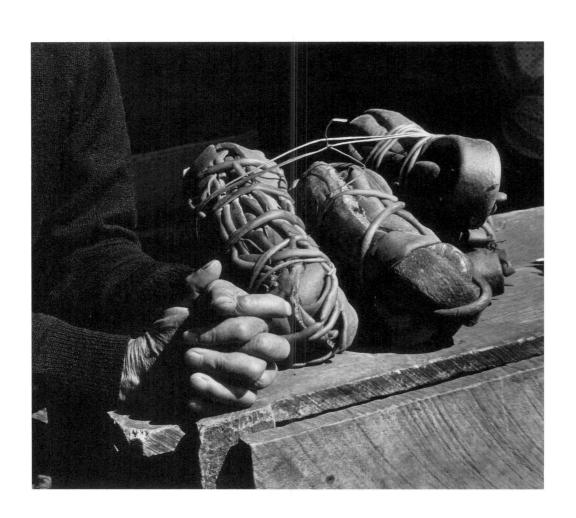

The Old Women of the Shore

To the grave sea come the old women
with shawls knotted around them,
on frail and brittle feet.

They sit themselves on the shore
without changing eyes or hands,
without changing clouds or silence.

The obscene sea breaks and scrapes,
slides down trumpeting mountains,
shakes out its bulls' beards.

The unruffled women sitting
as though in a glass boat
look at the savaging waves.

Where are they going, where have they been?
They come from every corner,
they come from our own life.

Now they have the ocean,
the cold and burning emptiness,
the solitude full of flames.

They come out of all the past,
from houses which once were fragrant,
from burnt-out twilights.

They watch or don't watch the sea,
they scrawl marks with a stick,
and the sea wipes out their calligraphy.

The old women rise and go
on their delicate birds' feet,
while the great roistering waves
roll nakedly on in the wind.

Translated by Alastair Reid

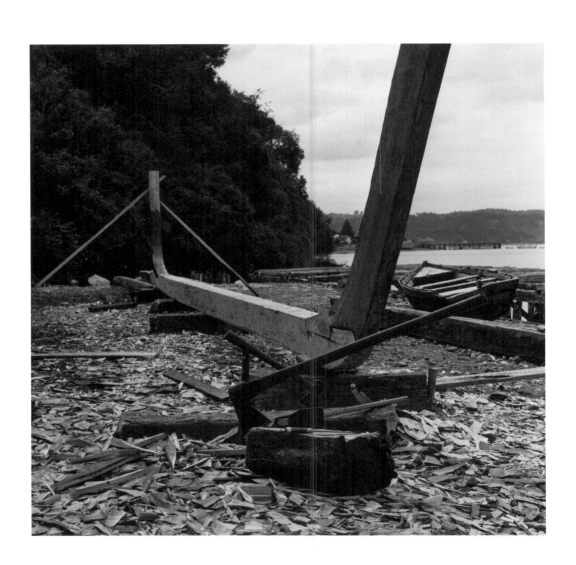

The Builder

I chose my own illusion,
from frozen salt I made its likeness—
I based my time on the great rain
and, even so, I am still alive.

It is true that my long mastery
divided up the dreams
and without my knowing there arose
walls, separations, endlessly.

Then I went to the coast.

I saw the beginnings of the ship,
I touched it, smooth as the sacred fish—
it quivered like the harp of heaven,
the woodwork was clean,
it had the scent of honey.
And when it did not come back,
the ship did not come back,
everyone drowned in his own tears
while I went back to the wood
with an ax naked as a star.

My faith lay in those ships.

I have no recourse but to live.

Translated by Alastair Reid

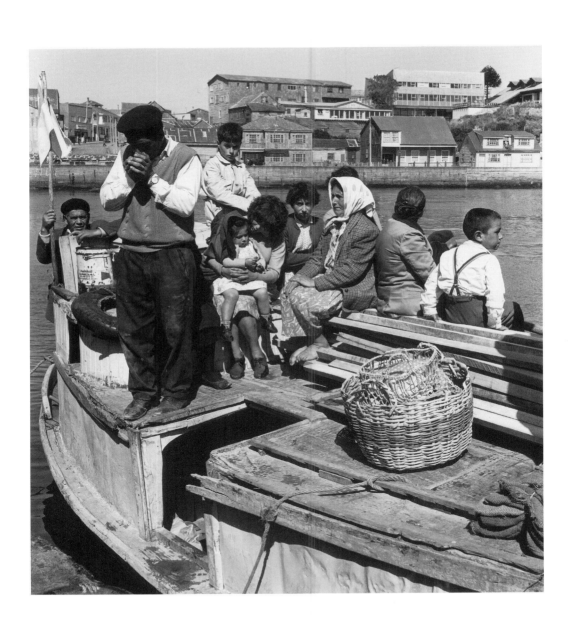

Farewell to the Offerings of the Sea

Return, return to the sea
from these pages!

Fishes, mollusks, seaweed,
escapees from the cold,
return to the waist
of the Pacific,
to the giddy kiss
of the wave, to the secret
logic of rock.

Oh hidden ones,
naked ones, submerged ones,
slippery ones,
it is the time
of division and separation:
paper reclaims me,
the ink, the inkwells,
the printing presses, the letters,
the illustrations,
the characters and numbers
jumbled in riverbeds from
where
they ambush me: the women,
and the men
want my love,
ask for my company,
the children from Petorca,
from Atacama, from Arauco,
from Loncoche,
also want to play with the poet!

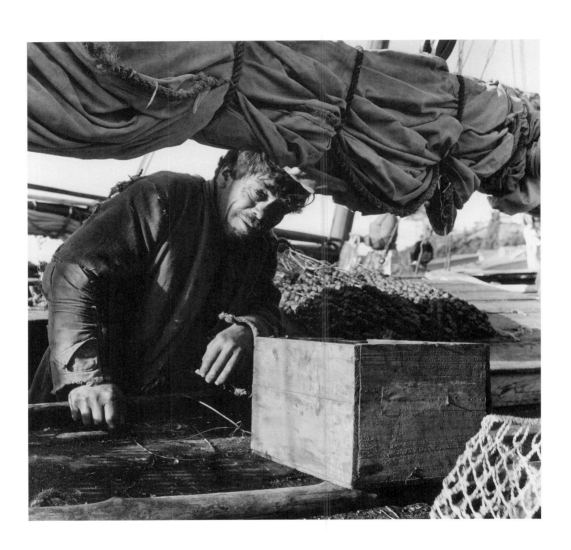

A train waits for me, a ship
loaded with apples,
an airplane, a plough,
some thorns.
Goodbye, harvested
fruits of the water, farewell,
imperially dressed
shrimps,
I will return, we will return
to the unity
now interrupted.
I belong to the sand:
I will return to the round sea
and to its flora
and to its fury:
but for now, I'll wander
whistling
through the streets.

Translated by Dennis Maloney

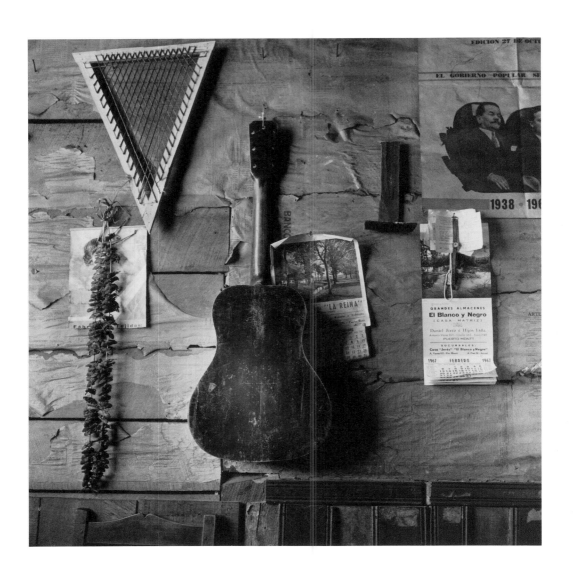

Hymn and Return

(1939)

Country, my country, I turn my blood in your direction.
But I am begging you the way a child begs its mother,
with tears:
 take this blind guitar
and these lost features.
I left to find sons for you over the earth,
I left to comfort those fallen with your name made of snow,
I left to build a house with your pure timber,
I left to carry your star to the wounded heroes.

Now I want to fall asleep in your substance.
Give me your clear night of piercing strings,
your night like a ship, your altitude covered with stars.

My country: I want to change my shadow.
My country: I want to have another rose.
I want to put my arm around your narrow waist
and sit down on your stones whitened by the sea
and hold the wheat back and look deep into it.
I am going to pick the thin flower of nitrate,
I am going to feel the icy wool of the field,
and staring at your famous and lonesome sea-foam
I'll weave with them a wreath on the shore for your beauty.

Country, my country,
entirely surrounded by aggressive water
and fighting snow,
the eagle and the sulphur come together in you,
and a drop of pure human light
burns in your antarctic hand of ermine and sapphire,
lighting up the hostile sky.

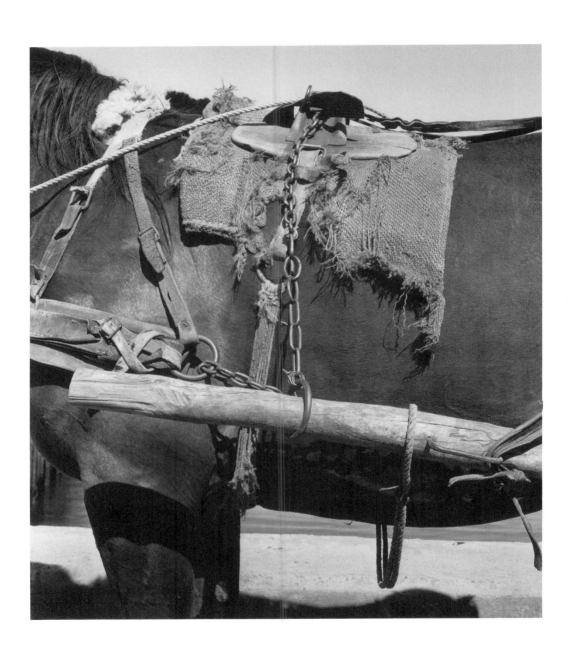

My country, take care of your light! Hold up
your stiff straw of hope
into the blind and frightening air.
All of this difficult light has fallen on your isolated land,
this future of the race,
that makes you defend a mysterious flower
alone, in the hugeness of an America that lies asleep.

Translated by Robert Bly

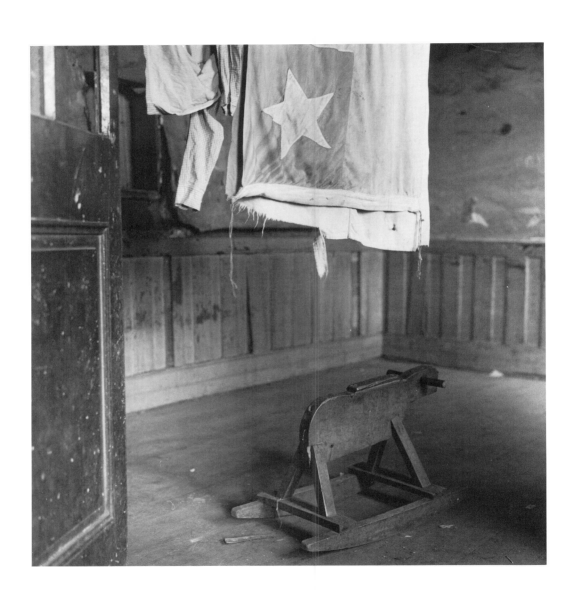

The United Fruit Company

When the trumpet sounded, it was
all prepared on the earth,
and Jehovah parceled out the earth
to Coca-Cola, Inc., Anaconda,
Ford Motors, and other entities:
The Fruit Company, Inc.
reserved for itself the most succulent,
the central coast of my own land,
the delicate waist of America.
It rechristened its territories
as the "Banana Republics"
and over the sleeping dead,
over the restless heroes
who brought about the greatness,
the liberty and the flags,
it established the comic opera:
abolished the independences,
presented crowns of Caesar,
unsheathed envy, attracted
the dictatorship of the flies,
Trujillo flies, Tacho flies,
Carias flies, Martinez flies,
Ubico flies, damp flies
of modest blood and marmalade,
drunken flies who zoom
over the ordinary graves,
circus flies, wise flies
well trained in tyranny.

Among the bloodthirsty flies
the Fruit Company lands its ships,
taking off the coffee and the fruit;
the treasure of our submerged
territories flows as though
on plates into the ships.

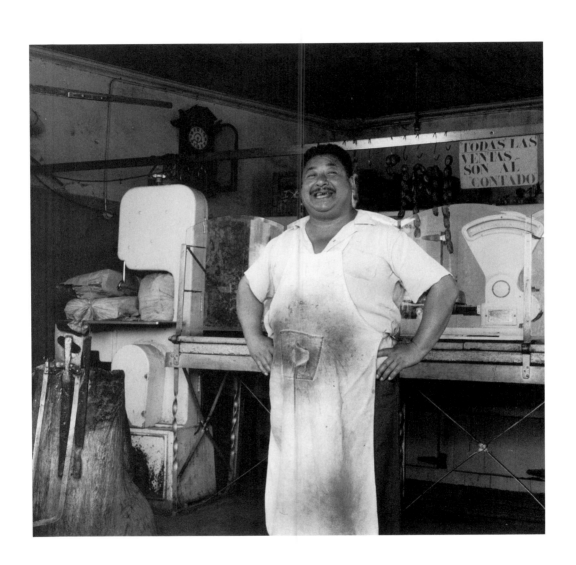

Meanwhile Indians are falling
into the sugared chasms
of the harbors, wrapped
for burial in the mist of the dawn:
a body rolls, a thing
that has no name, a fallen cipher,
a cluster of dead fruit
thrown down on the dump.

Translated by Robert Bly

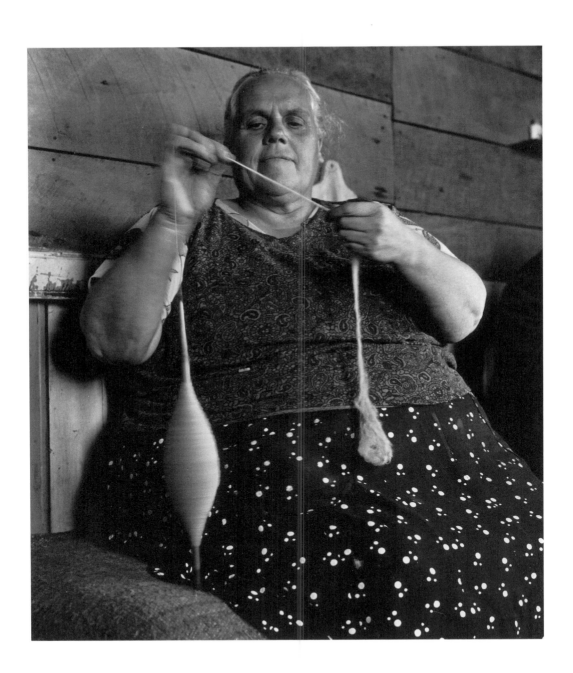

Ode to My Socks

Maru Mori brought me
a pair
of socks
which she knitted herself
with her sheepherder's hands,
two socks as soft
as rabbits.
I slipped my feet
into them
as though into
two
cases
knitted
with threads of
twilight
and goatskin.
Violent socks,
my feet were
two fish made
of wool,
two long sharks
sea-blue, shot
through
by one golden thread,
two immense blackbirds,
two cannons:
my feet were honored
in this way
by
these
heavenly
socks.
They were so handsome
for the first time
my feet seemed to me
unacceptable
like two decrepit
firemen, firemen
unworthy

of that woven
fire.
Of those glowing socks.

Nevertheless
I resisted
the sharp temptation
to save them somewhere
as schoolboys
keep
fireflies,
as learned men
collect
sacred texts,
I resisted
the mad impulse
to put them
into a golden
cage
and each day give them
birdseed
and pieces of pink melon.
Like explorers
in the jungle who hand
over the rare
green deer
to the spit
and eat it
with remorse,
I stretched out
my feet
and pulled on
the magnificent
socks
and then my shoes.

The moral
of my ode is this:
beauty is twice
beauty
and what is good is doubly
good
when it is a matter of two socks
made of wool
in winter.

Translated by Robert Bly

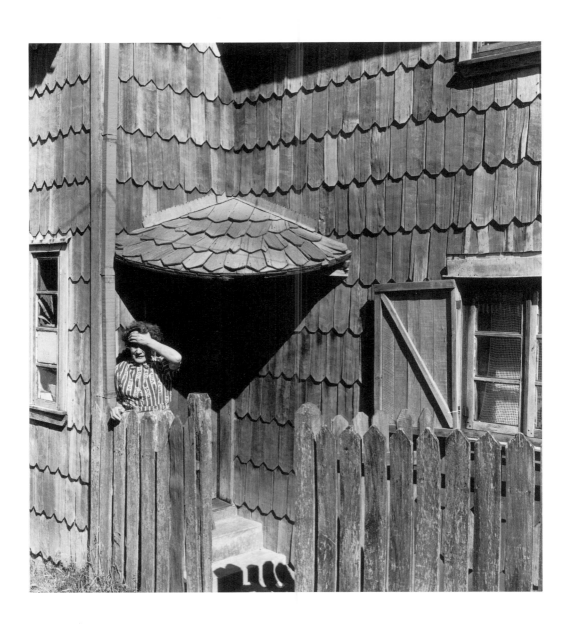

The Portrait in the Rock

Yes, I knew him. I lived years
with him, with his substance of gold and stone.
He was a man who was worn down.
In Paraguay he left his father and mother,
his sons, his nephews,
his new in-laws,
his gate, his hens
and some half-opened books.
They called him to the door.
When he opened it, the police took him
and they beat him so badly
that he spat blood in France, in Denmark,
in Spain, in Italy, traveling,
and so he died and I stopped seeing his face,
stopped hearing his profound silence.
Then once, on a stormy night,
with snow weaving
a pure coat on the mountains,
a horse, there, in the distance,
I looked and there was my friend:
his face was formed in stone,
his profile defied the wild weather,
in his nose the wind was muffling
the howls of the persecuted.
There the man driven from his land returned:
here in his country, he lives, transformed into stone.

<div align="right">Translated by Dennis Maloney</div>

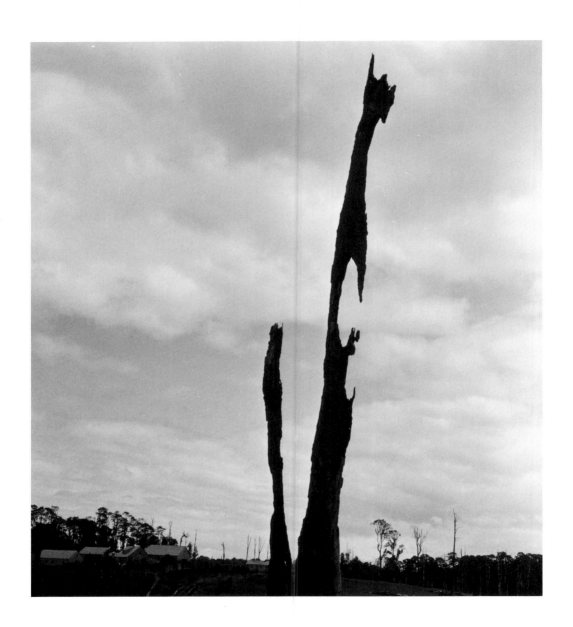

Oh, Earth, Wait for Me

Return me, oh sun,
to my country destiny,
rain of the ancient woods.
Bring me back its aroma, and the swords
falling from the sky,
the solitary peace of pasture and rock,
the damp at the river margins,
the smell of the larch tree,
the wind alive like a heart
beating in the crowded remoteness
of the towering aracucaria.

Earth, give me back your pristine gifts,
towers of silence which rose from
the solemnity of their roots.
I want to go back to being what I haven't been,
to learn to return from such depths
that among all natural things
I may live or not live. I don't mind
being one stone more, the dark stone,
the pure stone that the river bears away.

Translated by Alastair Reid

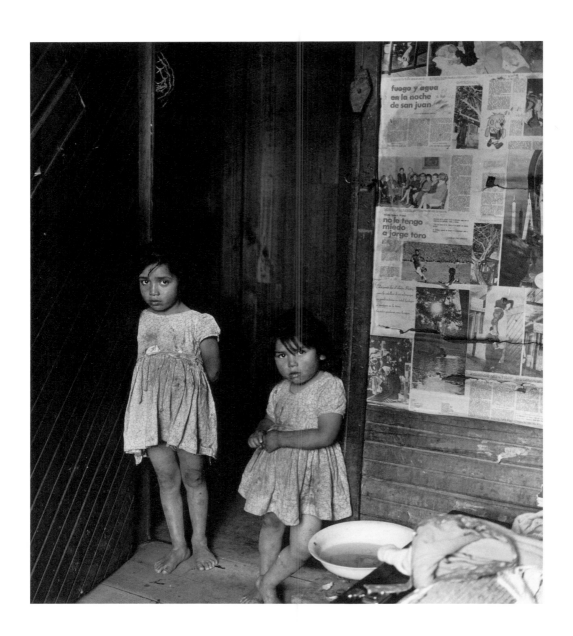

To Wash a Child

Love, the most immemorial on earth,
washes and combs the effigy of the children,
straightens the feet and knees;
the water rises, the soap slithers,
and the pristine body emerges to breathe
the air of flowers and the mother.

Oh, the sharp watchfulness,
the sweet deceptions,
the loving struggle!

Now the hair is a tangled
pelt crisscrossed by charcoal,
by sawdust and oil,
soot, wires, and crabs,
until love patiently,
patiently,
sets up buckets and sponges,
combs and towels,
and from scrubbing and combing and amber,
from ancient scruples and from jasmine,
emerges the child, cleaner than ever,
running from the mother's arms
to clamber again on its whirlwind,
to look for mud, oil, piss, and ink,
to hurt itself, tumble about on the stones.
In that way, newly washed, the child leaps into life:
for later it will have time for nothing more
than keeping clean, but lifelessly by then.

Translated by Alastair Reid

79

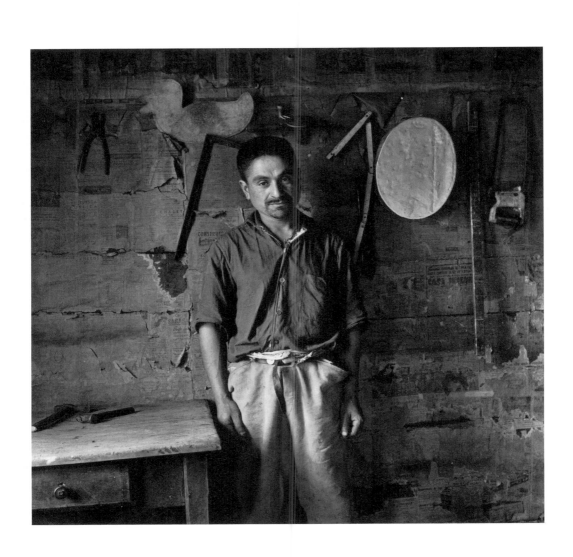

Letter to Miguel Otero Silva, in Caracas

<center>(1948)</center>

Nicolas Guillen brought me your letter, written
invisibly, on his clothes, in his eyes.
How happy you are, Miguel, both of us are!
In a world that festering plaster almost covers
there is no one left aimlessly happy but us.
I see the crow go by; there's nothing he can do to harm me.
You watch the scorpion, and polish your guitar.
Writing poetry, we live among the wild beasts, and when we touch
a man, the stuff of someone in whom we believed,
and he goes to pieces like a rotten pie,
you in the Venezuela you inherited gather together
whatever can be salvaged, while I cup my hands
around the live coal of life.
<div align="right">What happiness, Miguel!</div>
Are you going to ask where I am? I'll tell you—
giving only details useful to the State—
that on this coast scattered with wild rocks
the sea and the fields come together, the waves and the pines,
petrels and eagles, meadows and foam.
Have you ever spent a whole day close to sea birds,
watching how they fly? They seem
to be carrying the letters of the world to their destinations.
The pelicans go by like ships of the wind,
other birds go by like arrows, carrying
messages from dead kings, viceroys,
buried with strands of turquoise on the Andean coasts,
and seagulls so magnificently white,
they are constantly forgetting what their messages are.
Life is like the sky, Miguel, when we put
loving and fighting in it, words that are bread and wine,
words they have not been able to degrade even now,
because we walk out in the street with poems and guns.
They don't know what to do with us, Miguel.
What can they do but kill us; and even that
wouldn't be a good bargain—nothing they can do
but rent a room across the street, and tail us
so they can learn to laugh and cry like us.

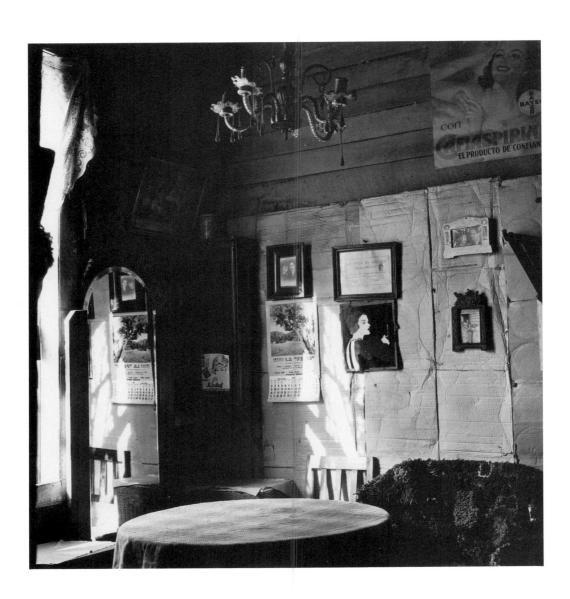

When I was writing my love poems, which sprouted out from me
on all sides, and I was dying of depression,
nomadic, abandoned, gnawing on the alphabet,
they said to me: "What a great man you are, Theocritus!"
I am not Theocritus: I took life,
and I faced her and kissed her,
and then went through the tunnels of the mines
to see how other men live.
And when I came out, my hands stained with garbage and sadness,
I held my hands up and showed them to the generals,
and said: "I am not a part of this crime."
They started to cough, showed disgust, left off saying hello,
gave up calling me Theocritus, and ended by insulting me
and assigning the entire police force to arrest me
because I didn't continue to be occupied exclusively with metaphysical subjects.
But I had brought joy over to my side.
From then on I started getting up to read the letters
the sea birds bring from so far away,
letters that arrive moist, messages I translate
phrase by phrase, slowly and confidently: I am punctilious
as an engineer in this strange duty.

All at once I go to the window. It is a square
of pure light, there is a clear horizon
of grasses and crags, and I go on working here
among the things I love: waves, rocks, wasps,
with an oceanic and drunken happiness.
But no one likes our being happy, and they cast you
in a genial role: "Now don't exaggerate, don't worry,"
and they wanted to lock me up in a cricket cage, where there would be tears,
and I would drown, and they could deliver elegies over my grave.

I remember one day in the sandy acres
of the nitrate flats; there were five hundred men
on strike. It was a scorching afternoon
in Tarapaca. And after the faces had absorbed all the sand and the bloodless
dry sun of the desert,
I saw coming into me, like a cup that I hate,
my old depression. At this time of crisis,
in the desolation of the salt flats, in that weak moment
of the fight, when we could have been beaten,

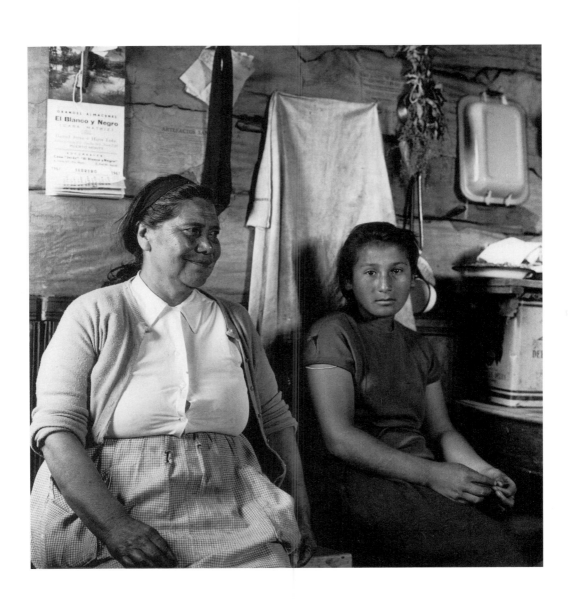

a little pale girl who had come from the mines
spoke a poem of yours in a brave voice that had glass in it and steel,
an old poem of yours that wanders among the wrinkled eyes
of all the workers of my country, of America.
And that small piece of your poetry blazed suddenly
like a purple blossom in my mouth,
and went down to my blood, filling it once more
with a luxuriant joy born from your poem.
I thought of you, but also of your bitter Venezuela.

Years ago I saw a student who had marks on his ankles
from chains ordered on him by a general,
and he told me of the chain gangs that work on the roads
and the jails where people disappeared forever. Because that is what our
America has been:
Long stretches with destructive rivers and constellations
of butterflies (in some places the emeralds are heavy as apples).
But along the whole length of the night and the rivers
there are always bleeding ankles, at one time near the oil wells,
now near the nitrate, in Pisagua, where a rotten leader
has put the best men of my country under the earth to die, so he can sell their
bones.
That is why you write your songs, so that someday the disgraced and wounded
America
can let its butterflies tremble and collect its emeralds
without the terrifying blood of beatings, coagulated
on the hands of the executioners and the businessmen.
I guessed how full of joy you would be, by the Orinco, singing
probably, or perhaps buying wine for your house,
taking your part in the fight and the exaltation,
with broad shoulders, like the poets of our age—
with light clothes and walking shoes.
Ever since that time, I have been thinking of writing to you,
and when Guillen arrived, running over with stories of you,
which were coming loose everywhere out of his clothes
—they poured out under the chestnuts of my house—
I said to myself: "Now!" and even then I didn't start a letter to you.

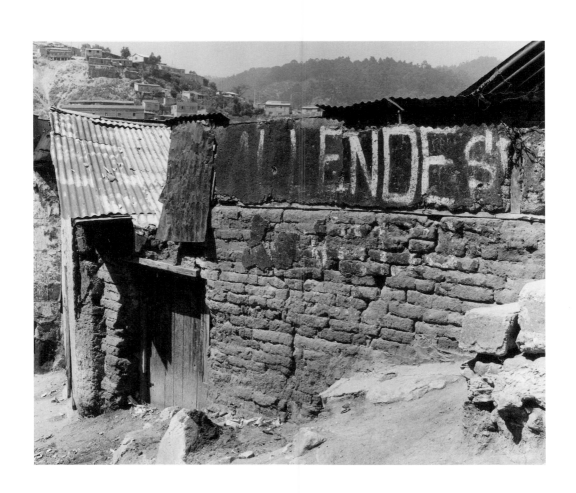

But today has been too much for me; not only one sea bird,
but thousands have gone past my window,
and I have picked up the letters no one reads, letters they take along
to all the shores of the world until they lose them.
Then in each of those letters I read words of yours,
and they resembled the words I write, and dream of, and put in poems,
and so I decided to send this to you, which I end here,
so I can watch through the window the world that is ours.

Translated by Robert Bly

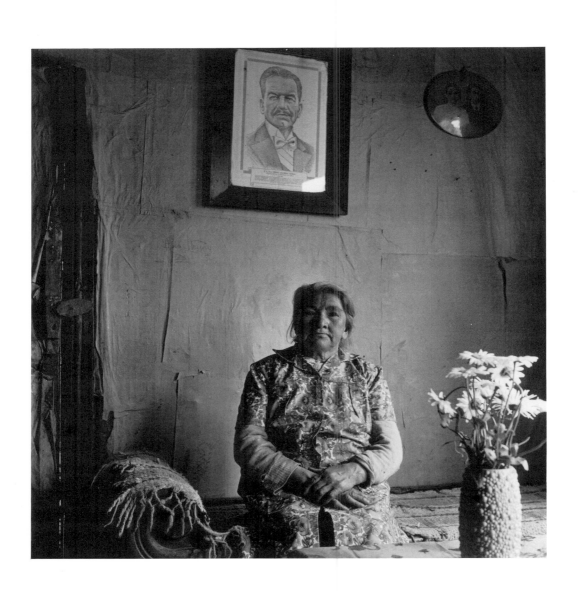

Memory

I have to remember everything,
keep track of blades of grass, the threads
of all untidy happenings
the resting places, inch by inch,
the infinite railroad tracks,
the surfaces of pain.

If I were to misplace one rosebush
and confuse night with a hare,
or even if one whole wall
of my memory were to disintegrate,
I am obliged to make over the air,
steam, earth, leaves,
hair, even the bricks,
the thorns which pierced me,
the speed of flight.

Be gentle with the poet.

I was always quick to forget
and those hands of mine
could only grasp intangibles,
untouchable things,
which could only be compared
when they no longer existed.

The smoke was like an aroma,
the aroma something like smoke,
the skin of a sleeping body
which came to life with my kisses;
but don't ask me the date
or the name of what I dreamed—
nor can I measure the road
which may have no country,
or that truth that changed,
or perhaps turned off by day
to become a wandering light
a firefly in the dark.

Translated by Alastair Reid

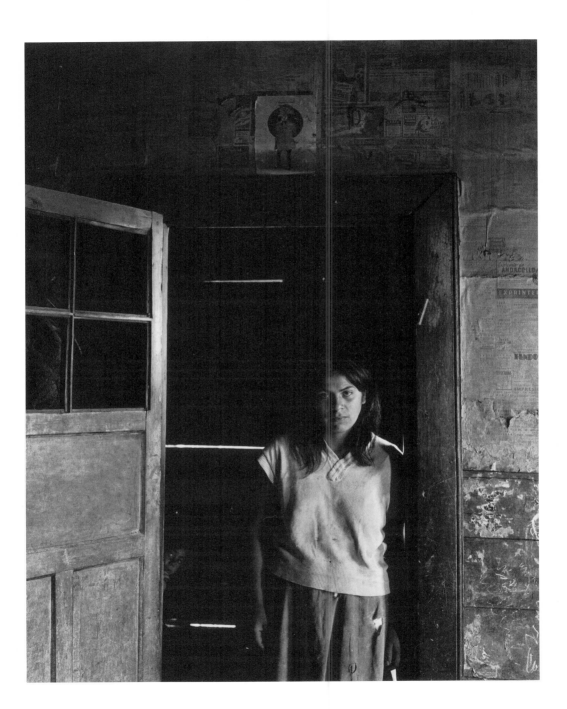

from *Twenty Poems of Love and One Poem of Despair*

6

I remember you as you were that final autumn.
You wore a grey beret and the whole being at peace.
In your eyes the fires of the evening dusk were battling,
and the leaves were falling in the waters of your soul.

As attached to my arms as a morning glory,
your sad, slow voice was picked up by the leaves.
Bonfire of astonishment in which my thirst was burning.
Soft blue of hyacinth twisting above my soul.

I feel your eyes travel and the autumn is distant:
gray beret, voice of a bird, and heart like a house
toward which my profound desires were emigrating
and my thick kisses were falling like hot coals.

The sky from a ship. The plains from a hill:
your memory is of light, of smoke, of a still pool!
Beyond your eyes the evening dusks were battling.
Dry leaves of autumn were whirling in your soul.

Translated by Robert Bly

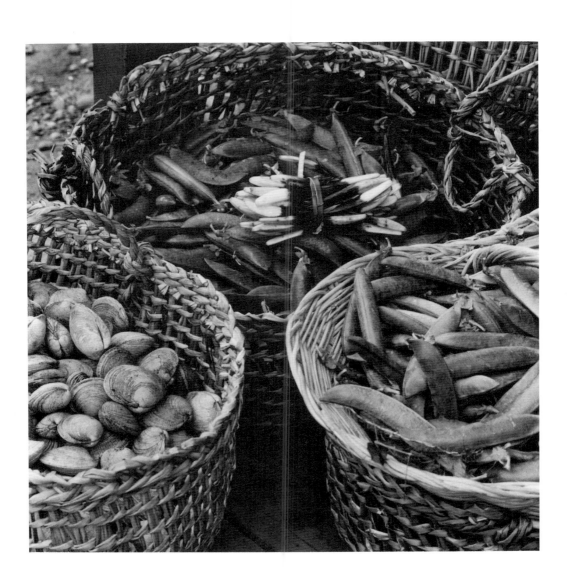

Fish Market

Fish hang by their tails,
the spilled fish shine,
the fish display their silver,
even the crabs still threaten.
On the huge decorated table,
through the submarine scales,
only the body of the sea is missing.
It does not die; it is not for sale.

Translated by Dennis Maloney

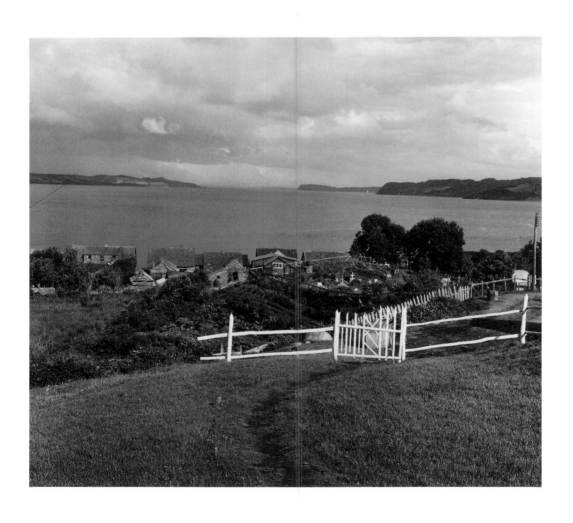

I Will Return

Some other time, man or woman, traveler,
later, when I am not alive,
look here, look for me
between stone and ocean,
in the light storming
through the foam.
Look here, look for me,
for here I will return, without saying a thing,
without voice, without mouth, pure,
here I will return to be the churning
of the water, of
its unbroken heart,
here, I will be discovered and lost:
here, I will, perhaps, be stone and silence.

Translated by Dennis Maloney

Self-Portrait

How to arrange myself to seem bad and remain well? It is like when one looks at himself in the mirror (or the portrait) looking for the beautiful angel (without anyone observing it) to check that one keeps on being the same always.

Some plant themselves sideways, others will imprint the truth with that which they would like to be, others will ask themselves: How am I really?

But the truth is that we all live taking notes on ourselves, lying in ambush for our own selves, declaring only the most visible, and hiding the irregularity of the apprenticeship and of time... But, let's get to the point.

For my part I am or believe I am hard of nose, minimal of eyes, scarce of hair on the head, growing of abdomen, long-legged, wide-soled, yellow of face, generous in loves, impossible to calculate, confused with words, tender of hand, slow in going, unrustable heart; fan of the stars, tides, tidal waves; admirer of scarabs, walker of sands, slow of intuition. Chilean to perpetuity, friend of my friends, mute to enemies, intruder among birds, badly educated in the house, timid in the salons, audacious in solitude, repentant without object, a horrendous administrator, navigator of the mouth, stirrer of ink, discreet among animals, lucky in cloudbursts, investigator in the markets, dark in the libraries, melancholic in the mountains, untiring in the forests, very slow in answering, happening years later, vulgar throughout the year, resplendent with my notebook, monumental of appetite, a tiger for sleeping, quiet in joy, inspector of the nocturnal heavens, invisible worker, persistently irregular, valiant by necessity, coward without sin, sleepy by vocation, friendly with women, active through suffering, poet by malediction, and ignorant fool.

Translated by Janine Pommy Vega